Draw
Your Garden

CAROLE VINCER

Series editors: David and Brenda Herbert

A & C Black • London

First published 1982
New style of paperback binding 1996
by A&C Black (Publishers)
37 Soho Square
London W1D 3QZ

Reprinted 2001

ISBN 0-7136-6247-6

© A&C Black (Publishers)

Printed in Hong Kong by Wing King Tong

Cover photograph by Zul Mukhida

Contents

Making a start 4

What to draw with 6

What to draw on 8

Perspective 12

Composition 15

Structure and form 16

The structure of plants 18

Working within a framework 20

Shading and weight of line 22

A re-statement 24

Step-by-step: an urn 26

Building up a drawing 28

Working from the centre 30

Drawing with a pen 32

Drawing in charcoal 34

Using a wash 36

Garden visitors: birds 40

Garden visitors: butterflies 44

Garden visitors: snails 45

Texture 46

A final word 48

Making a start

Learning to draw is largely a matter of practice and observation — so draw as much and as often as you can, and use your eyes all the time.

Look around you — at chairs, tables, plants, people, buildings, your hand holding this book. Everything is worth drawing. The time you spend on a drawing is not important. A ten-minute sketch can say as much as a painstaking drawing that takes many hours.

Carry a sketchbook with you whenever possible, and don't be shy of using it in public, either for quick notes to be used later or for a finished drawing. Even if you do not have a garden of your own, you can take your sketchbook to a public garden or to a friend's garden. As well as flowers, trees and all kinds of vegetable plants, gardens can provide a wealth of other subjects, such as the wildlife that inhabits them, walls, steps, garden furniture, stools, trellises, brickwork and sheds.

To do an interesting drawing, you must enjoy it. Even if you start on something that doesn't particularly interest you, you will probably find that the act of drawing it — and looking at it in a new way — creates its own excitement. The less you think about how you are drawing and the more you think about what you are drawing, the better your drawing will be.

The best equipment will not itself make you a better artist — a masterpiece can be drawn with a stump of pencil on a scrap of paper. But good equipment is encouraging and pleasant to use, so buy the best you can afford and don't be afraid to use it freely.

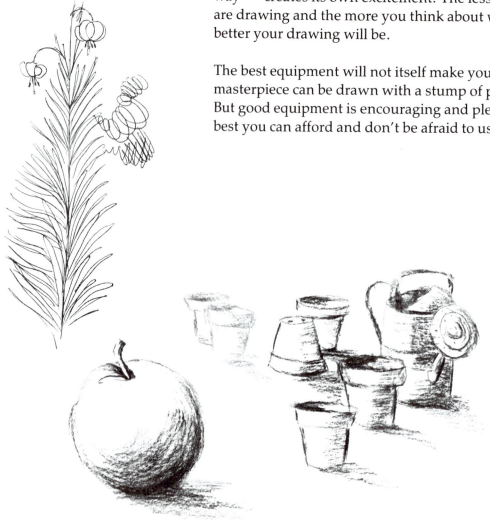

Be as bold as you dare. It's your piece of paper and you can do what you like with it. Experiment with the biggest piece of paper and the boldest, softest piece of chalk or crayon you can find, filling the paper with lines — scribbles, lettering, anything — to get a feeling of freedom.

Be self-critical. If a drawing looks wrong, scrap it and start again. A second, third or even fourth attempt will often be better than the first, because you are learning more about the subject all the time. Use an eraser as little as possible — piecemeal correction won't help. Don't retrace your lines. If a line is right the first time, leave it alone — heavier re-drawing leads to a dull, mechanical look.

You can learn a certain amount from copying other people's drawings. But you will learn more from a drawing done from direct observation of the subject or even out of your head, however stiff and unsatisfactory the results may seem at first.

A lot can be learned by practice and from books, but a teacher can be a great help. If you get the chance, don't hesitate to join a class — even one evening a week can do a lot of good.

What to draw with

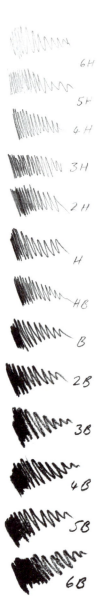

6H

5H

4H

3H

2H

H

HB

B

2B

3B

4B

5B

6B

Pencils are graded according to hardness, from 6H (the hardest) through 5H, 4H, 3H, 2H to H; then HB; then B, through 1B, 2B, 3B, 4B, 5B up to 6B (the softest). For most purposes, a soft pencil (HB or softer) is best. If you keep it sharp, it will draw as fine a line as a hard pencil but with less pressure, which makes it easier to control. Sometimes it is effective to smudge the line with your finger or an eraser, but if you do this too much the drawing will look woolly. A fine range of graphite drawing pencils is Royal Sovereign.

Charcoal (which is very soft) is excellent for large, bold sketches, but not for detail. If you use it, beware of accidental smudging A drawing can even be dusted or rubbed off the paper altogether. To prevent this, spray with fixative. Charcoal pencils, such as the Royal Sovereign, are also very useful.

Wax crayons (also soft) are not easily smudged or erased. You can scrape a line away from a drawing on good quality paper, or partly scrape a drawing to get special effects.

Conté crayons, wood-cased or in solid sticks, are available in various degrees of hardness, and three colours — black, red and white. The cased crayons are easy to sharpen, but the solid sticks are more fun — you can use the side of the stick for large areas of tone. Conté is harder than charcoal, but it is also easy to smudge. The black is very intense.

Pastels (available in a wide range of colours) are softer still. Since drawings in pastel are usually called 'paintings', they are really beyond the scope of this book.

Pens vary as much as pencils or crayons. Ink has a quality of its own, but of course it cannot be erased. Mapping pens are only suitable for delicate detail and minute cross-hatching.

Special artists' pens, such as Gillott 303 and Gillott 404 allow you a more varied line, according to the angle at which you hold them and the pressure you use. The Gillott 659 is a very popular crowquill pen.

Reed, bamboo and quill pens are good for bold lines and you can make the nib end narrower or wider with the help of a sharp knife or razor blade. This kind of pen has to be dipped frequently into the ink.

Fountain pens have a softer touch than dip-in pens, and many artists prefer them. The portability of the fountain pen makes it a very useful sketching tool.

Special fountain pens, such as Rapidograph and Rotring, control the flow of ink by means of a needle valve in a fine tube (the nib). Nibs are available in several grades of fineness and are interchangeable. The line they produce is of even thickness, but on coarse paper you can draw an interesting broken line similar to that of a crayon. These pens have to be held at a right-angle to the paper, which is a disadvantage.

Inks also vary. Waterproof Indian ink quickly clogs the pen. Pelikan Fount India, which is nearly as black, flows more smoothly and does not leave a varnishy deposit on the pen. Ordinary fountain-pen or writing inks (black, blue, green or brown) are less opaque, so give a drawing more variety of tone. You can mix water with any ink in order to make it thinner. But if you are using Indian ink, add distilled or rain water, because ordinary water will cause it to curdle.

Ball point pens make a drawing look a bit mechanical, but they are cheap and fool-proof and useful for quick notes and scribbles.

Fibre pens are only slightly better, and their points tend to wear down quickly.

Brushes are most versatile drawing instruments. The Chinese and Japanese know this and until recently never used anything else, even for writing. The biggest sable brush has a fine point, and the smallest brush laid on its side provides a line broader than the broadest nib. You can add depth and variety to a pen or crayon drawing by washing over it with a brush dipped in clean water.

Mixed methods are often pleasing. Try making drawings with pen and pencil, pen and wash or Conté and wash. And try drawing with a pen on wet paper. Pencil and Conté do not look well together and Conté will not draw over pencil or greasy surfaces.

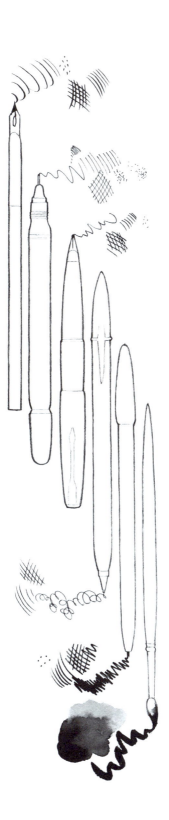

What to draw on

Try as many different surfaces as possible.

Ordinary, inexpensive paper is often as good as anything else: for example, brown and buff wrapping paper (Kraft paper) and lining for wallpaper have surfaces which are particularly suitable for charcoal and soft crayons. Some writing and duplicating papers are best for pen drawings. But there are many papers and brands made specially for the artist.

Bristol board is a smooth, hard white board designed for fine pen work.

Ledger Bond (cartridge in the UK), the most usual drawing paper, is available in a variety of surfaces — smooth, 'not surface' (semi-rough), rough.

Watercolour papers also come in various grades of smoothness. They are thick, high-quality papers, expensive but pleasant to use.

Ingres paper is mainly for pastel drawings. It has a soft, furry surface and is made in many light colours — grey, pink, blue, buff, etc.

Sketchbooks, made up from nearly all these papers, are available. Choose one with thin, smooth paper to begin with. Thin paper means more pages, and a smooth surface is best to record detail.

Lay-out pads make useful sketchbooks. Although their covers are not stiff, you can easily insert a stiff piece of card to act as firm backing to your drawing. The paper is semi-transparent, but this can be useful — almost as tracing paper — if you want to make a new, improved version of your last drawing.

An improvised sketchbook can be just as good as a bought one — or better. Find two pieces of thick card, sandwich a stack of paper, preferably of different kinds, between them and clip together at either end.

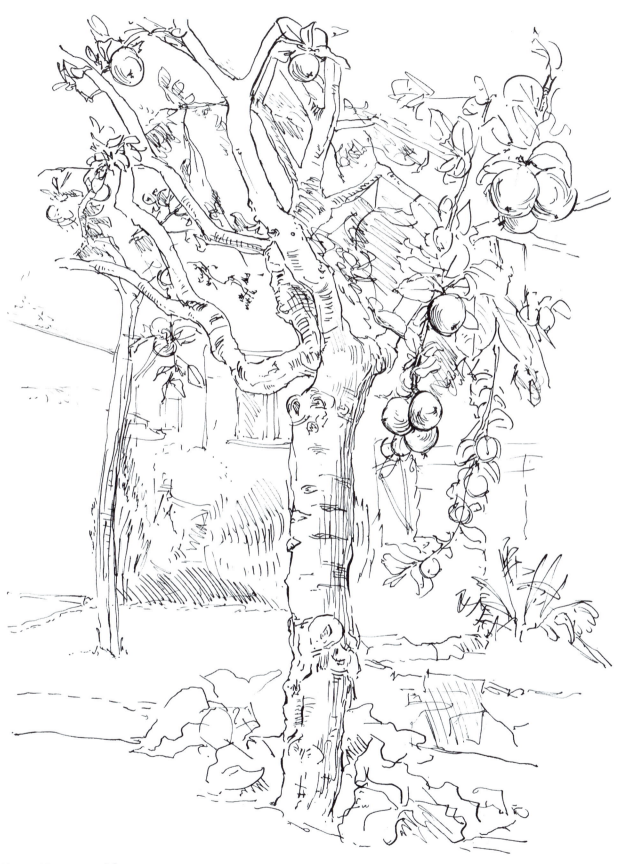

Gillott 303 on cartridge

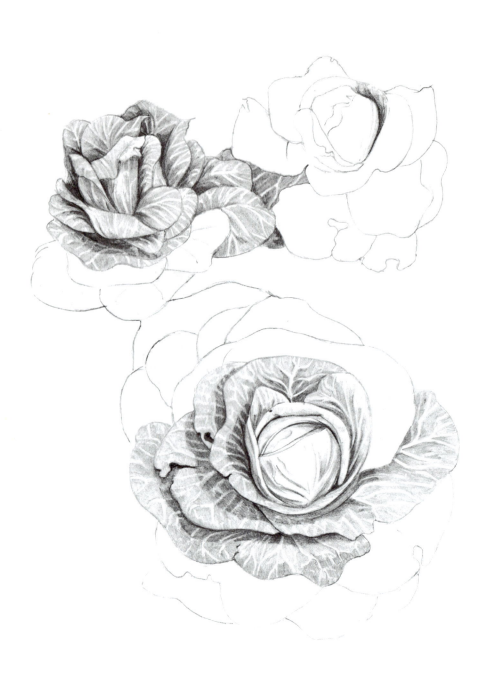

Above: hard pencil on very
smooth paper

Right: wash, pen, charcoal
and pencil on very smooth
paper

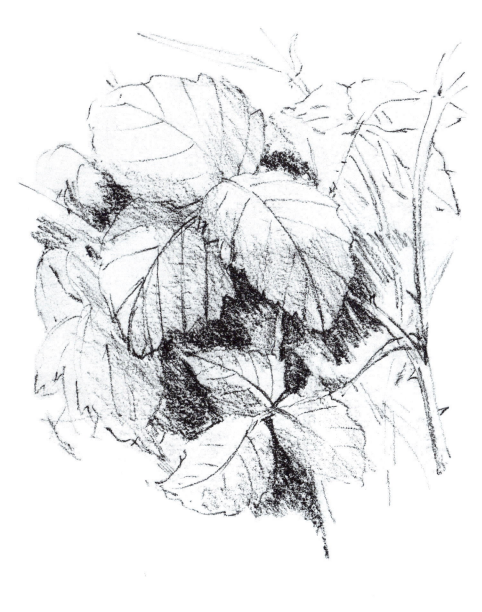

Above: charcoal on smooth
cartridge

Left: wash, pen, charcoal
and B pencil on watercolour
paper

Perspective

You can be an artist without knowing anything about perspective. Five hundred years ago, when some of the great masterpieces of all time were painted, the word did not even exist. But most beginners want to know something about it in order to make their drawings appear three-dimensional rather than flat, so here is a short guide.

The further away an object is, the smaller it seems.

All parallel horizontal lines that are directly opposite you, at right-angles to your line of vision, remain parallel.

All horizontal lines that are in fact parallel but go away from you will appear to converge at eye-level at the same vanishing point on the horizon. Lines that are *above* your eye-level will seem to run downwards towards the vanishing point; lines that are *below* your eye-level will run upwards. You can check the angles of these lines against a pencil held horizontally at eye-level.

The larger and closer any object is, the bigger the front of it will seem to be in relation to the part furthest away, or to any other more distant object. Its actual shape will appear foreshortened or distorted. A matchbox close to you will appear larger and more distorted than a distant house, and if you are drawing a building seen at an angle through a window, the window frame will be larger and more distorted than the building.

If the side of an object is facing you one vanishing point is enough (as in the matchbox drawing); but if the corner is facing you, two vanishing points will be needed.

It may even be necessary to use three vanishing points when your eye is well above or below an object, but these occasions are rare.

Diagonal lines drawn between the opposite angles of a square or rectangle will meet at a point which is half-way along its length or breadth. This remains true when the square or rectangle is foreshortened. You may find it helpful to remember this when you are drawing surfaces with equal divisions — for example, a tiled floor or the line of windows on a bus or a railway carriage.

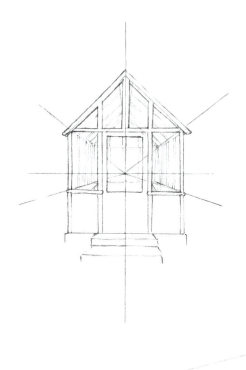

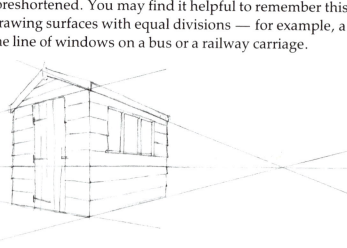

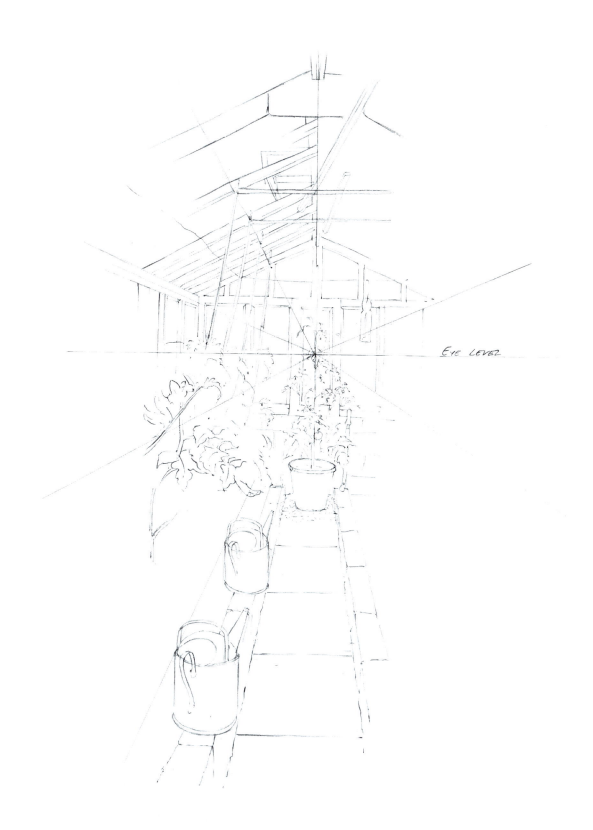

EYE LEVEL

When drawing a circular shape, the following is useful: a square drawn round a circle will touch the circle at the centre point of each of its sides. A foreshortened circle will turn into an oval, but will still touch the centre points of each side of a similarly foreshortened square. However distorted the square, the circle will remain a true oval but will seem to tilt as the square moves to left or right of the vanishing point. The same is true of half circles.

You will tend to exaggerate the apparent depth of top surfaces because you know they are square or rectangular and want to show this in your drawing.

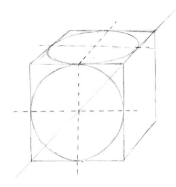

You can check the correct apparent depth of any receding plane by using a pencil or ruler held at eye-level and measuring the proportions on it with your thumb. If you use a ruler you can actually read off the various proportions.

One point to mention again: *all* receding parallel lines have the same vanishing point. So if, for instance, you draw a street this will apply to all the horizontal edges — roofs, doors, windows, lines of bricks, chimneys.

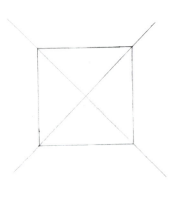

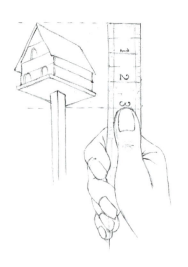

Composition

This does not only apply to large finished paintings. Deciding where to place even the smallest sketch or doodle on a scribbling pad involves composition. The effect of your drawing will be greatly influenced by its position on the paper and by how much space you leave around it.

It is generally best, when learning to draw, to make your drawing as large as possible on your piece of paper. But there are many possibilities. Sometimes you may not even want the whole of the object on your paper. And there is no reason why the paper should be the same shape as the subject — it is not, for instance, necessary to draw a tall object on an upright piece of paper.

When you are drawing more than one object on a sheet of paper, the placing of each object is also important. Try as many variations as possible. Before you begin a drawing, think about how you will place it on the paper — even a few seconds' thought may save you having to start your drawing again. Never distort your drawing in order to get it all in.

Alternatively cut a hole in a piece of card which is in proportion to your paper and hold it up to your subject. By moving it closer or further away from you, it is possible to adjust how much you want to show in your drawing.

Structure and form

Before drawing even the simplest object, try to understand its basic structure or form — as I have done with the watering can here. Look closely and ask yourself what is the fundamental shape. Draw this shape and then build up the total structure by relating other parts of the object to it. Once you have produced a structured drawing, you can add details which will give it character.

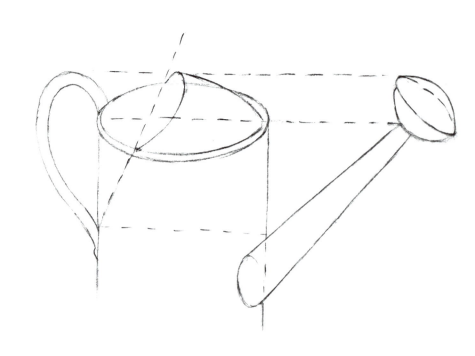

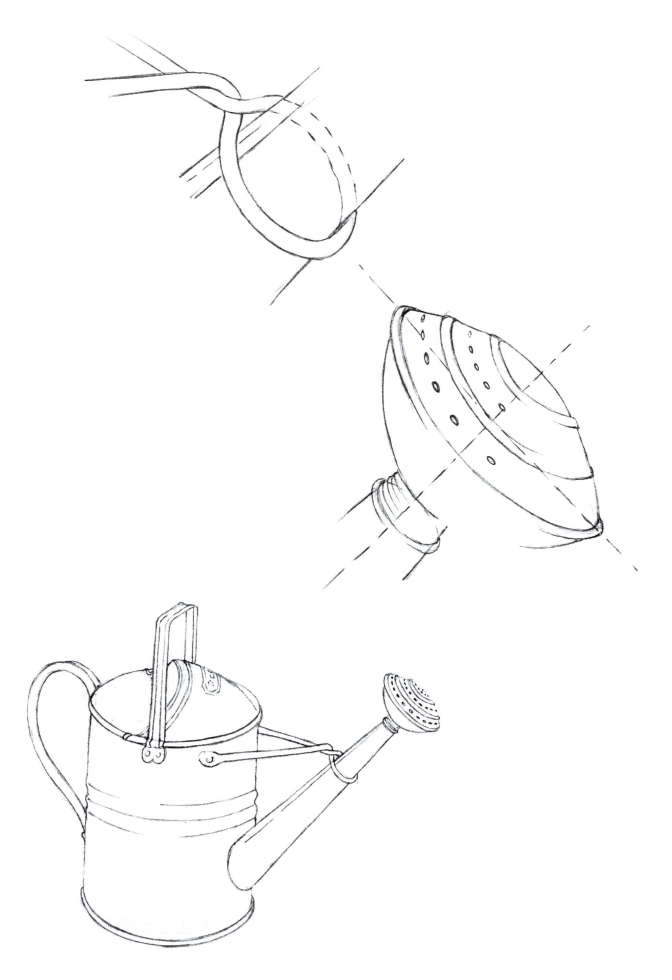

The structure
of plants

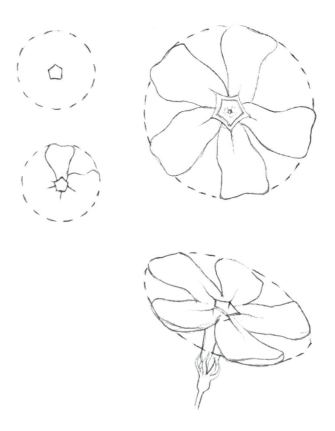

To grasp the structure of a plant, study how it grows before you start
an actual drawing. Make a series of exploratory sketches.

Try drawing a flower within a circle; then, remembering how the
perspective of a circle changes (page 14), tilt the circle in different
directions until you can draw the flower correctly at any angle.

The position and appearance of leaves can vary greatly. Once again,
you need first of all to understand their basic shape (and the
arrangement of the veins) *before* sketching them at angles.

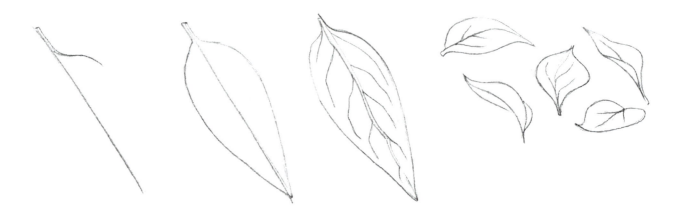

When you feel you understand the plant's basic structure and how it grows, you can move on with confidence to make a drawing of the whole plant, adding detail and perhaps a colour wash. When drawing leaves in position it helps to follow through lines that are in fact hidden, if you imagine the leaves as transparent.

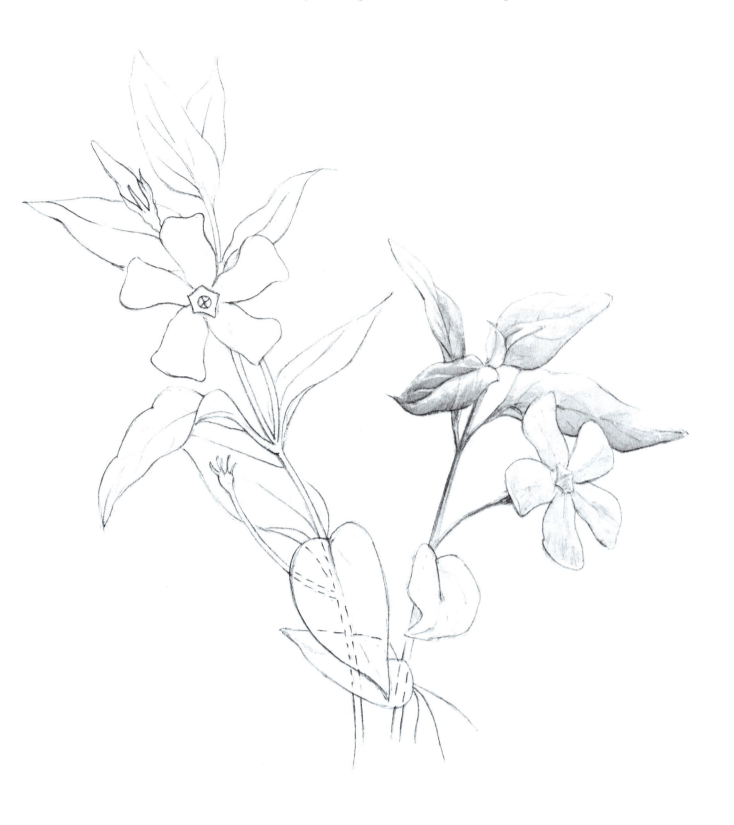

Working within a framework

Try drawing a plant, such as a creeper, which relates to a rigid structure, such as a fence or wall. The relationship between the two will enable you to work within a set area and also keep the drawing in proportion.

Draw the structure first (the struts of a fence in this case). Then position the plant within the chosen framework. Concentrate on the shapes of the leaves. When you have established the basic shape of the whole plant, you can add such details as the veins on the leaves, which will begin to give substance to the drawing.

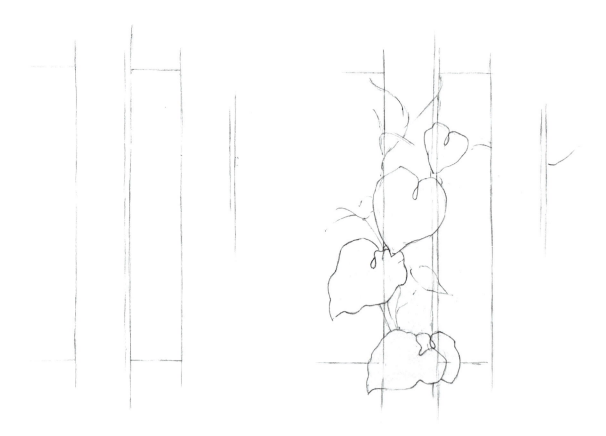

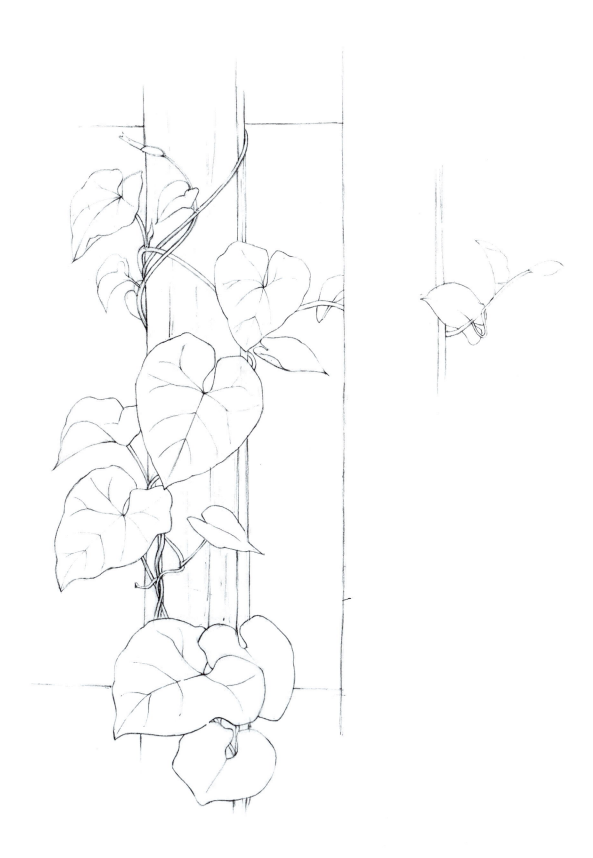

Shading
and weight
of line

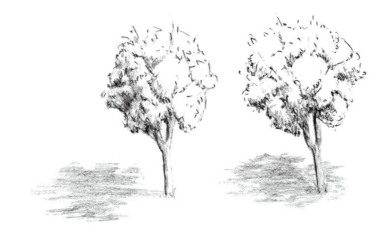

You can use shading to represent depth or the effect of light or a sense of colour (see page 39) — sometimes all three. So think what you are trying to represent before you apply your pencil.

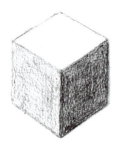

Depth and light can be represented by a single line. Compare the apple drawings here: notice that the line becomes thicker where there is an area of shade. Notice, too, the different effect created by light falling on square and round objects, and the changing effects of light during the course of a day — shown in these tree drawings.

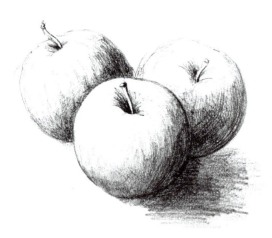

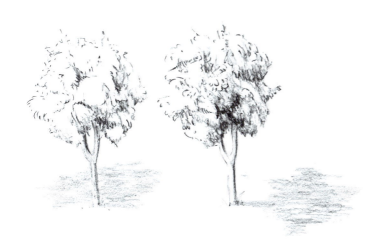

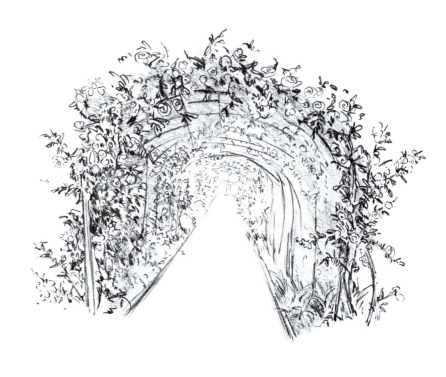

The two rose arbour drawings demonstrate how line and shade can be used to represent depth, by darkening *either* the part furthest away *or* the part closest to you.

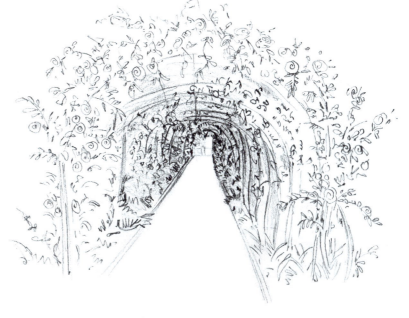

23

A re-statement

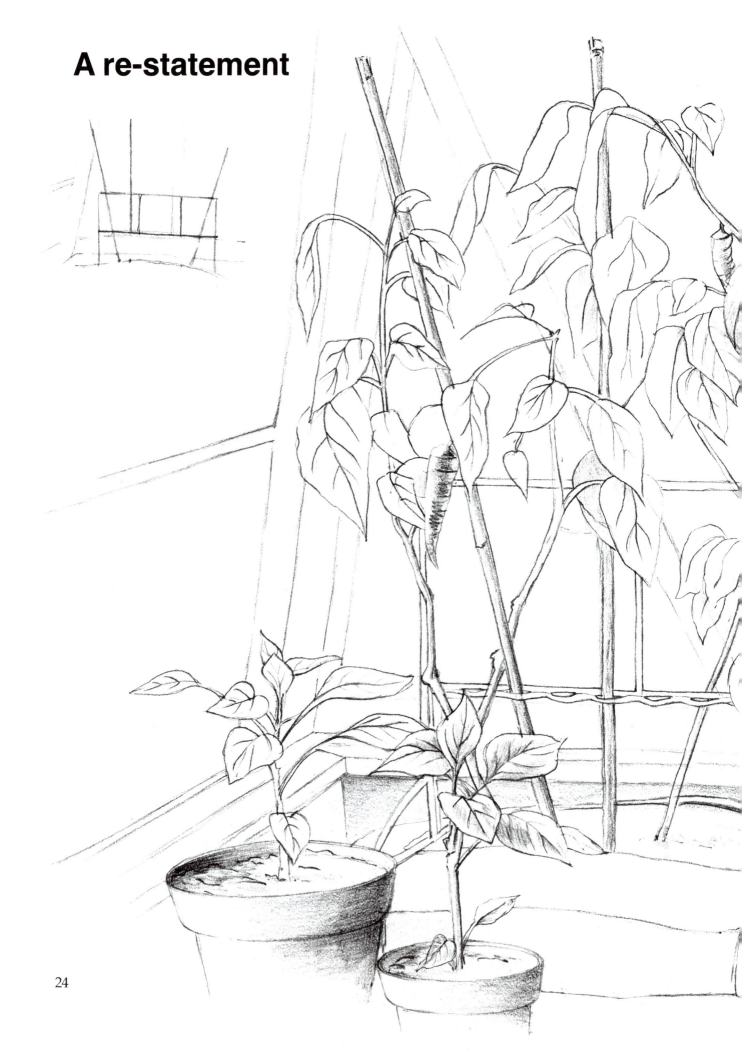

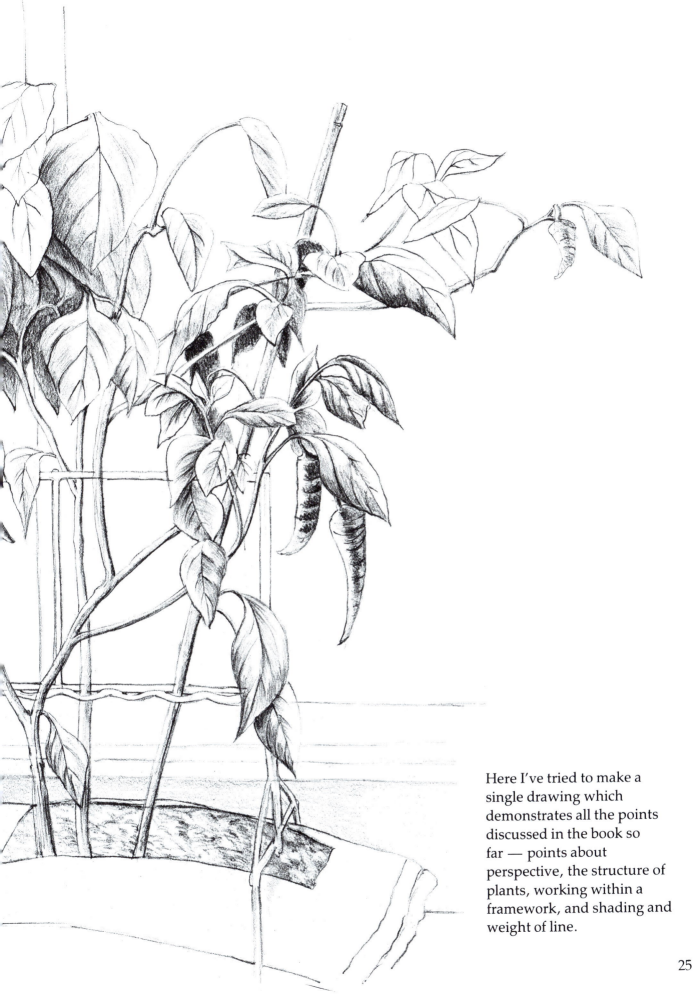

Here I've tried to make a single drawing which demonstrates all the points discussed in the book so far — points about perspective, the structure of plants, working within a framework, and shading and weight of line.

25

Step-by-step: an urn

Try a drawing that will show a contrast between hard and soft objects. An urn with flowers in it is a good example. First of all, express the basic structure of the urn. Then, after careful examination, add the pattern to build up the overall shape. Finally, put in the flowers and add further detail and shading. Tone has been used here to represent light and also to suggest the texture of the stone. Notice also that the stone has a hard, continuous line, and the flowers a more delicate, broken one.

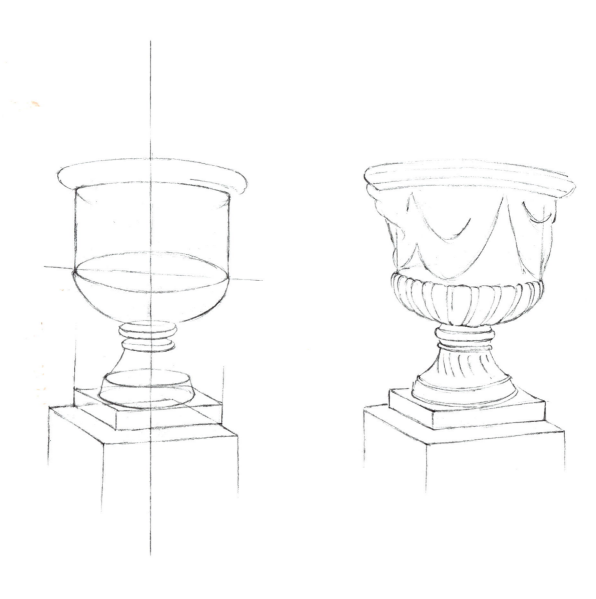

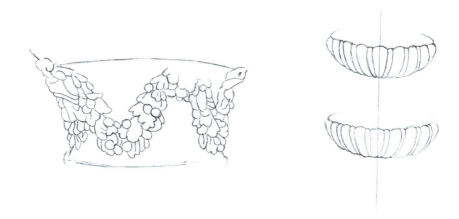

Never assume too much; the base of the urn may not be symmetrical. And never draw what you cannot see — those parts of the urn, for example, which are obscured by overhanging plants.

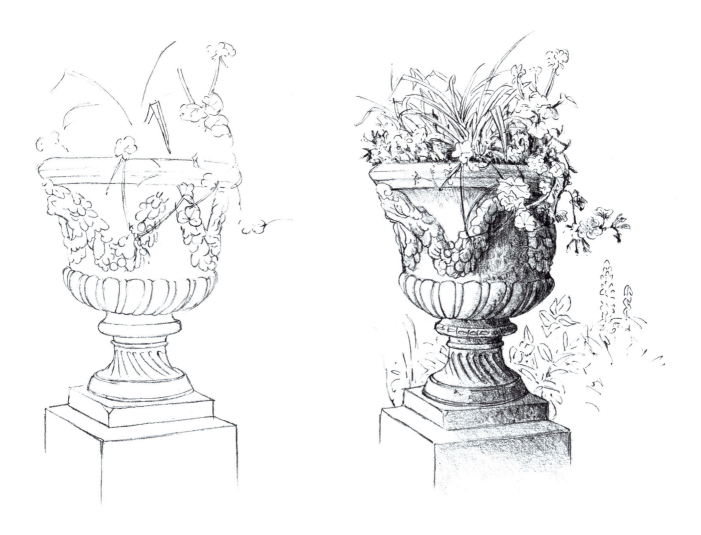

Building up
a drawing

This is only one way — but a good one — to build up a composite drawing from scratch. By following it, you can organise the picture on the page before looking at detail. I started by establishing the basic pattern of the vegetable garden, and then isolated the different areas, marking in the divisions between the vegetables. From there I went on to draw the vegetables themselves and bring out their individual textures. I've used shading to represent light.

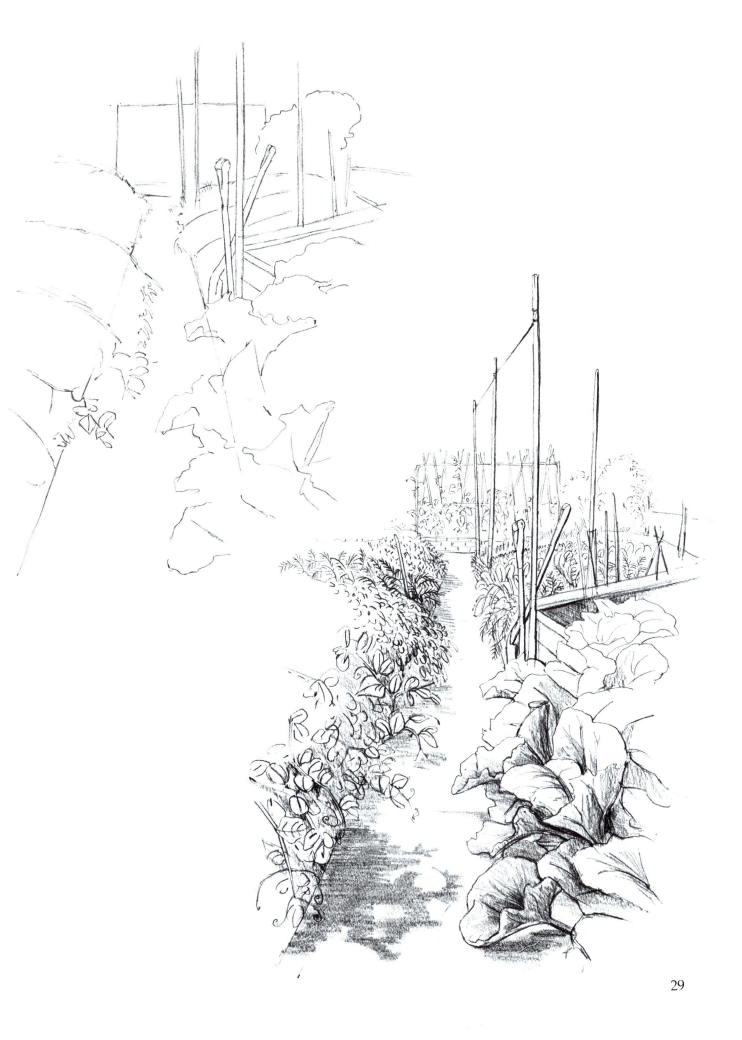

Working from the centre

This is another good way to build up a drawing. Decide on the central point, and then work outwards relating each new object (vertically and horizontally) to its position from the centre. It's best to plot your way through points on the paper that are the same distance from each other. As the drawing progresses you may find yourself relating new points to several earlier ones, but continue to concentrate on their relationship with the centre — which will help to keep the whole drawing in proportion. As described on page 14, you can measure vertical and horizontal distances by holding a pencil or ruler at arm's length against the scene in front of you. Further detail can be filled in later. When drawing foliage of distant trees, don't try to reproduce leaves in detail: go for the basic shape and texture.

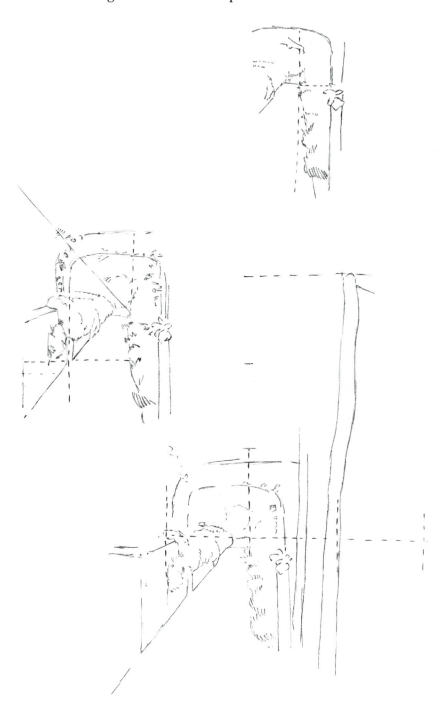

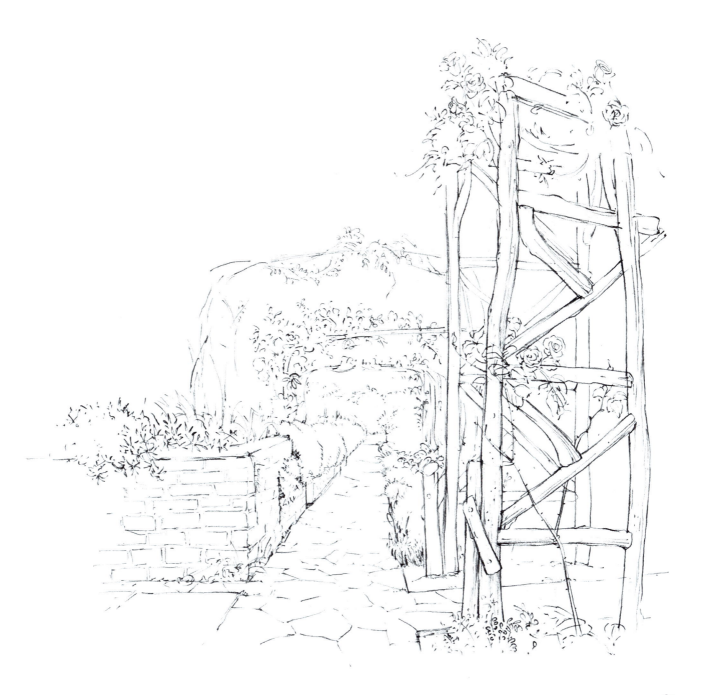

Drawing with a pen

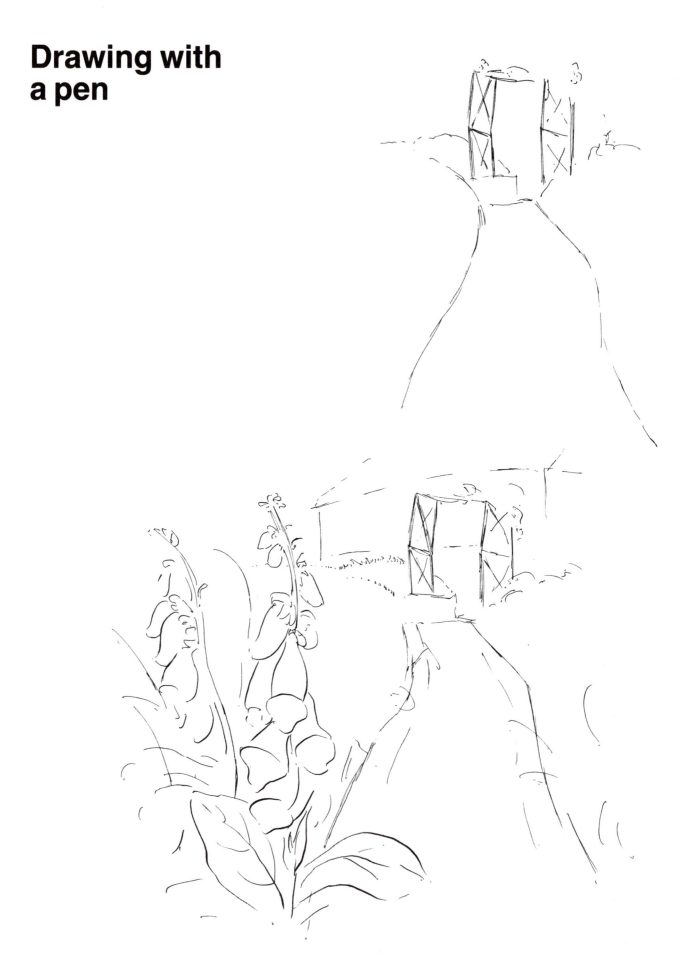

Since ink lines cannot be erased, drawing with a pen is usually a more spontaneous business than drawing with a pencil. It can also produce more lively pictures. If you make a wrong mark, ignore it and carry on; you will find that most mistakes become lost as the drawing progresses.

With this cottage garden, I concentrated on the relationship between distance and foreground: notice that weight of line plays an important role.

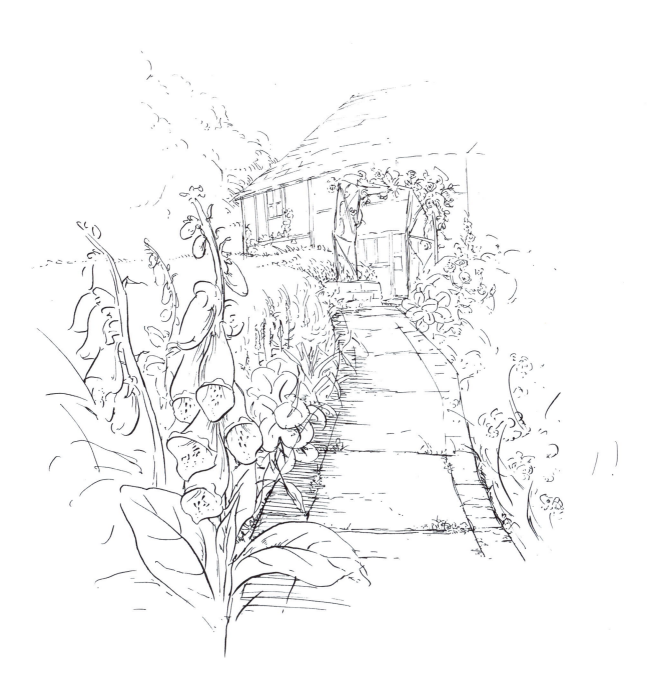

Drawing
in charcoal

Charcoal is the best medium for 'contrasty' drawings. After roughly marking in a few guidelines, build up your picture by relating dark and light areas to each other. It sometimes helps to half shut your eyes as you look at the scene in front of you so that detail disappears and areas of shade become more noticeable.

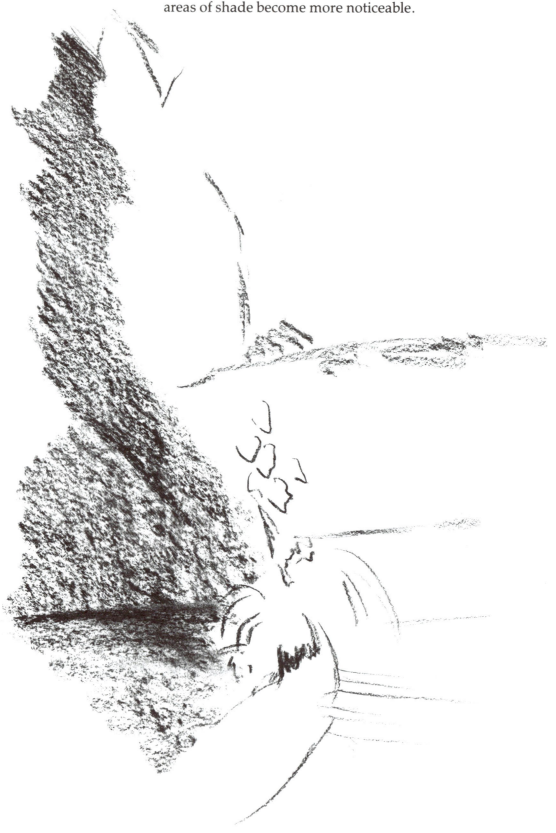

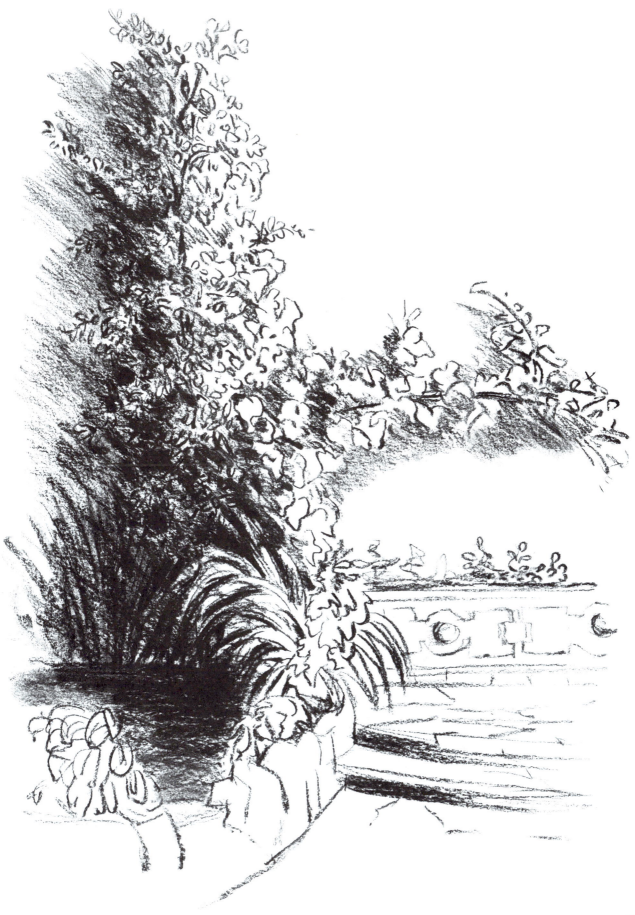

Using a wash

You can use a wash on its own — as shown opposite — or with another medium such as pen or pencil. Pencil and wash can be used alternately as you go along; but if you use a pen, it is best to sketch everything first, allow the ink time to dry, and then add the wash.

Choose a thick cartridge or watercolour paper (thin paper cockles easily) and take care not to swamp it with water. Keep a tissue handy to wipe excess water from your brush. You can build up tones by painting darker washes over light ones.

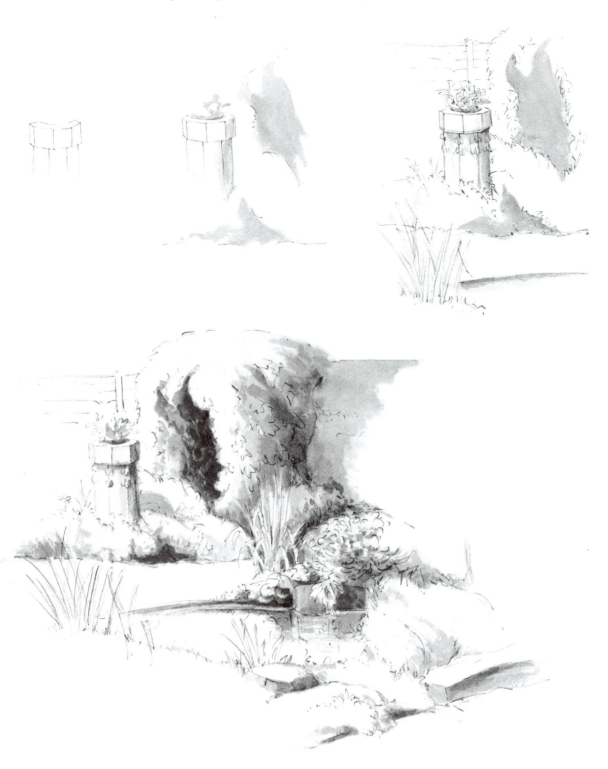

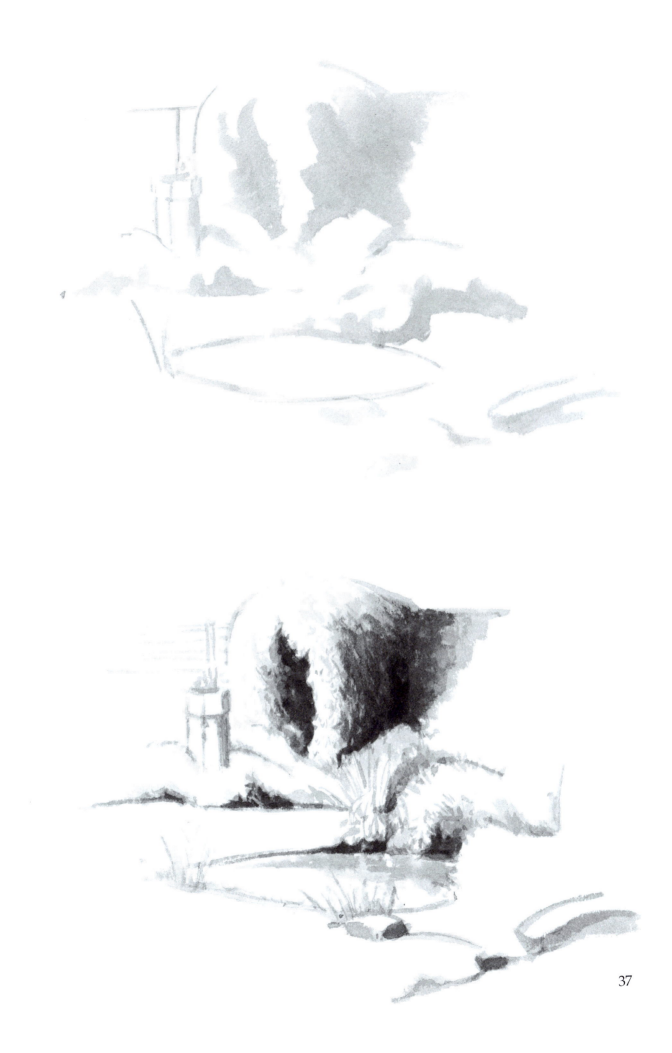

Compare the pen and wash sketches on these two pages. In the first, the wash has been used to represent the effect of light. In the second, the variety of tone gives a sense of colour.

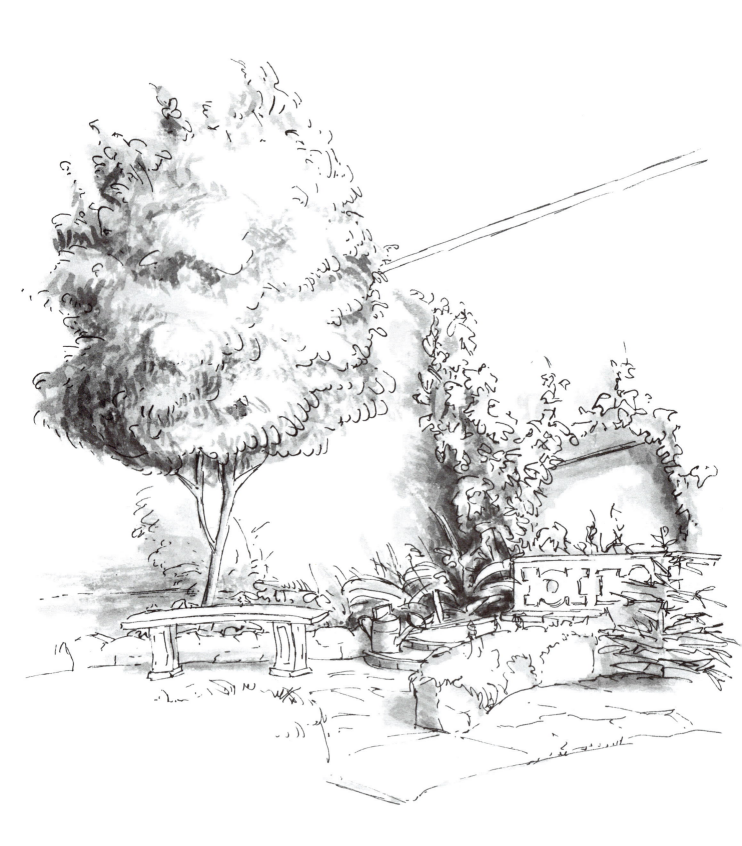

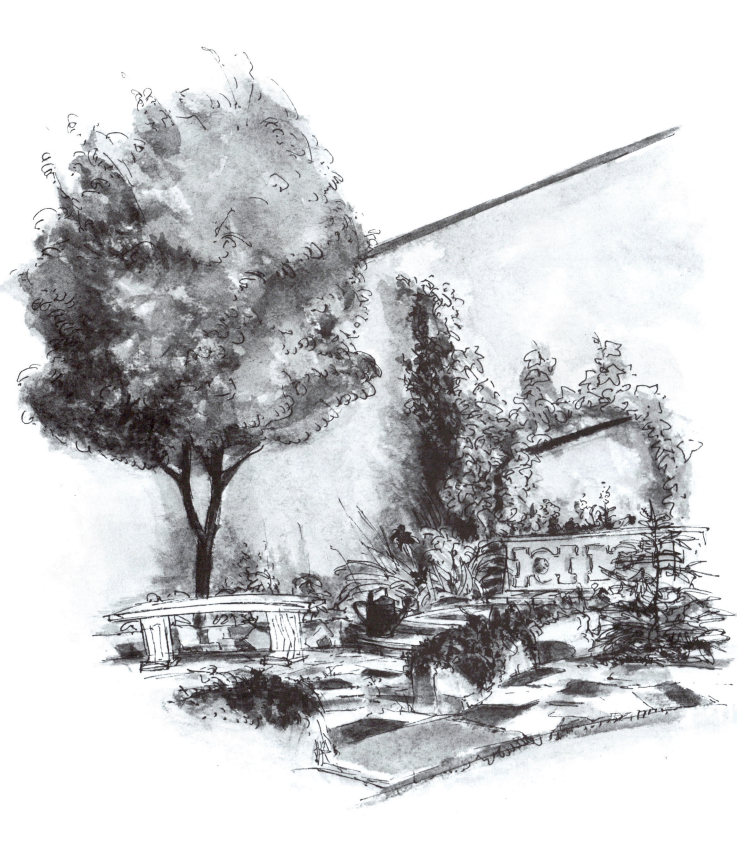

Garden visitors: birds

Birds are the commonest garden visitors. Always on the move, they aren't easy to capture with a pen, but its great fun trying. You need a lot of patience and a lot of practice in very quick sketching. Don't try to draw a live bird in detail. Your 'sitters' probably won't show themselves when you are

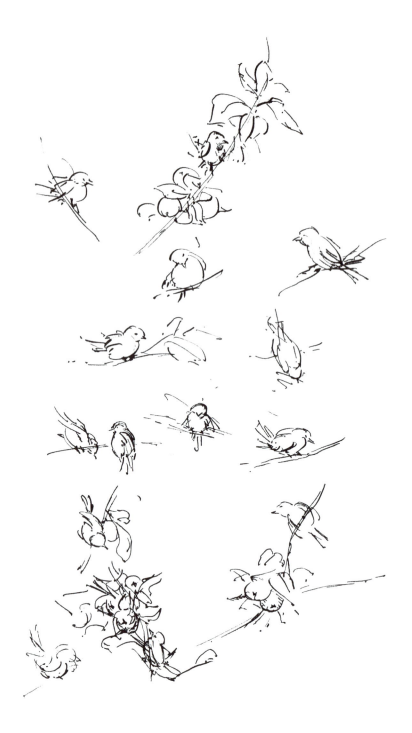

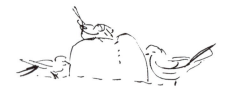

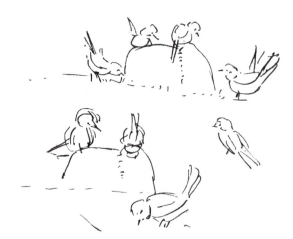

ready to draw; you may need to bribe them with food on a bird table. Try covering a page with bird tables and then sketching in the birds as they arrive. Don't be disheartened if the first few pages contain nothing but scribbles. You will have had excellent practice in discovering how to reproduce a form with the simplest and most important of lines, and some valid sketches will soon emerge.

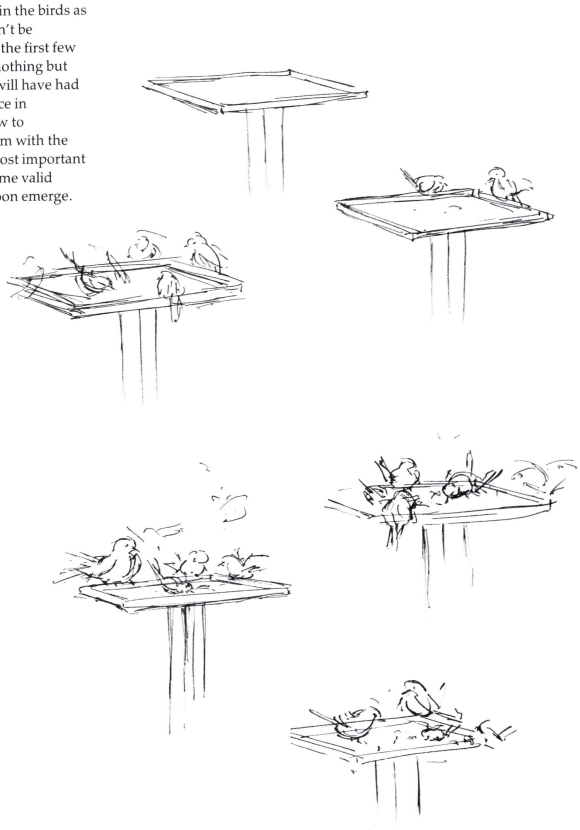

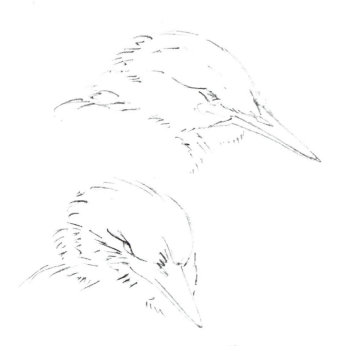

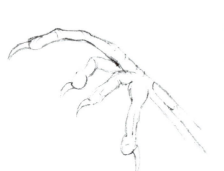

If you find a dead bird, in good condition, take the opportunity to study its structure. Make separate sketches of feet, head, wing and plumage, and draw each in several different positions. Then draw the whole bird with the understanding you now have of the form of the various parts.

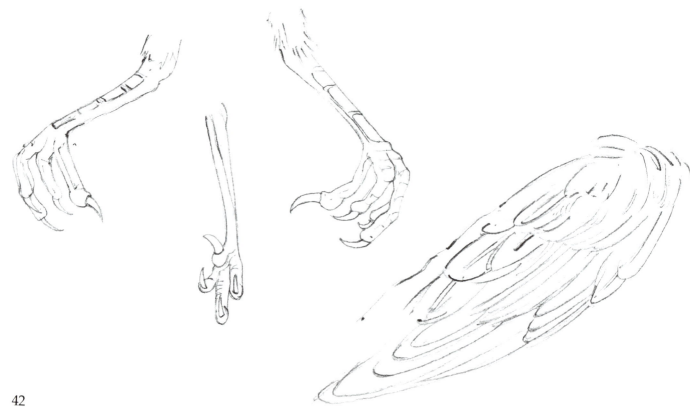

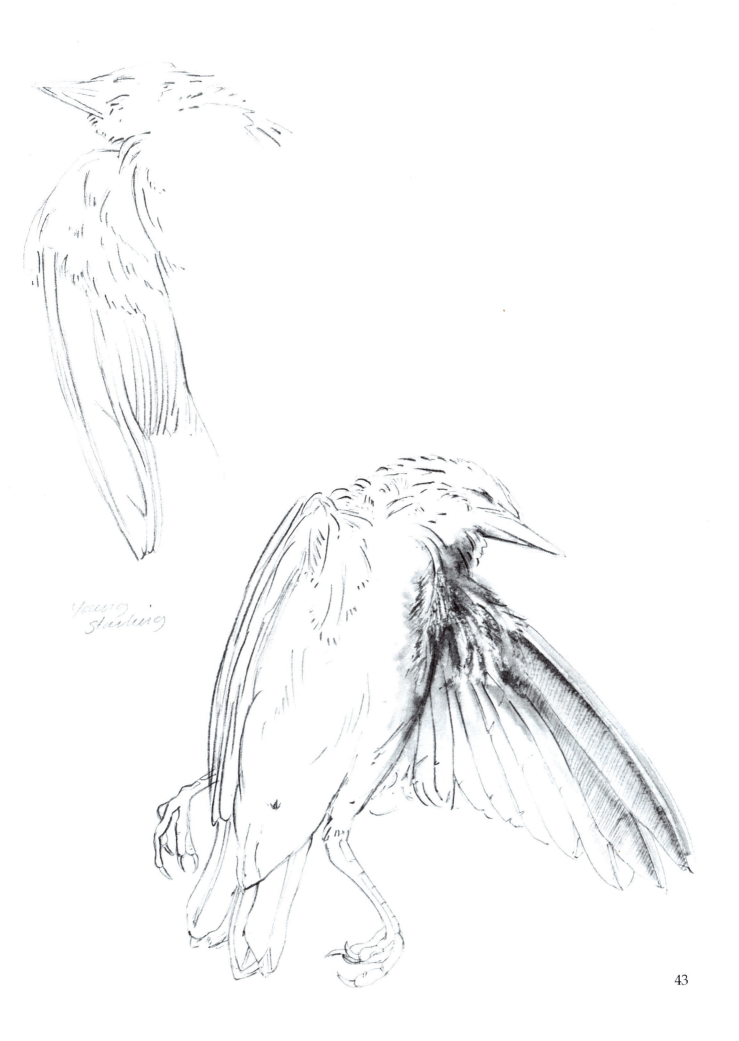

Young
Starling

43

Garden visitors: butterflies

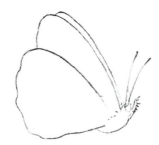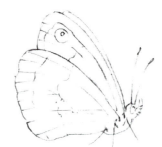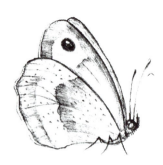

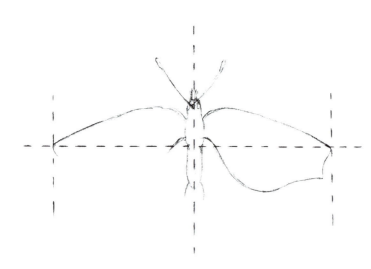

If a butterfly settles on a nearby flower while you are drawing, seize the opportunity to sketch it quickly. For closer study, capture it in a glass jar. Start a profile drawing with the wings, adding first the body then the wing markings, and shading to suggest colour. It is useful to know that one open butterfly wing mirrors the other. You can therefore either draw one wing at a time or repeat each mark in reverse on the opposite wing as you go along. It is easier to position the pattern if you draw in the veins first.

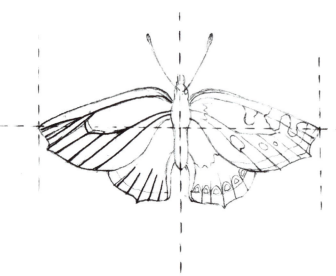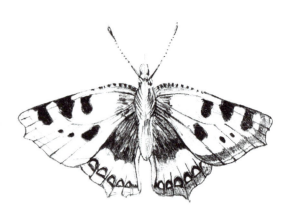

Garden visitors: snails

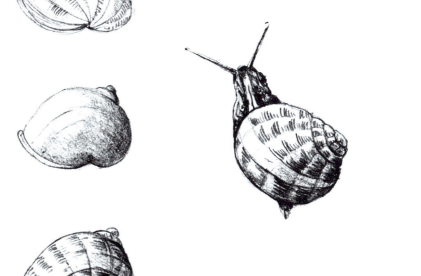

Snails aren't always slow-moving — especially if you want to draw them! So when you find one, put it on a shallow dish or tray and sketch quickly. If it moves halfway through, sketch the new position and finish the first drawing when it returns to where it was. Concentrate on the basic structure of the shell, observing its pattern and how light falls on it. Then make a drawing showing pattern and light. Finally add a snail to the shell.

Texture

Pens and pencils are very versatile and can be used to describe any texture. Here are some examples with a rotring pen, and some (softer ones) with a pencil.

Several varieties are shown together in the pen drawing below. To represent texture well, you must feel for what you draw. A flower (for example) requires a more delicate approach than a wall or tree.

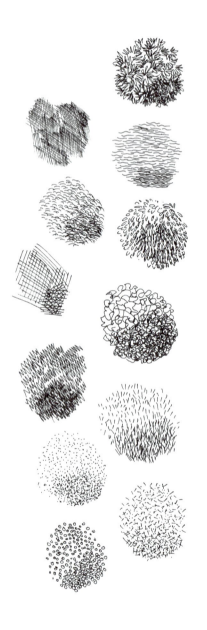

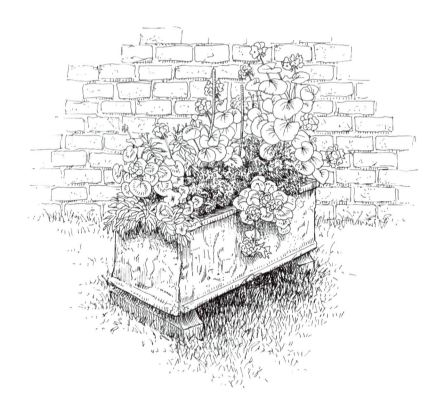

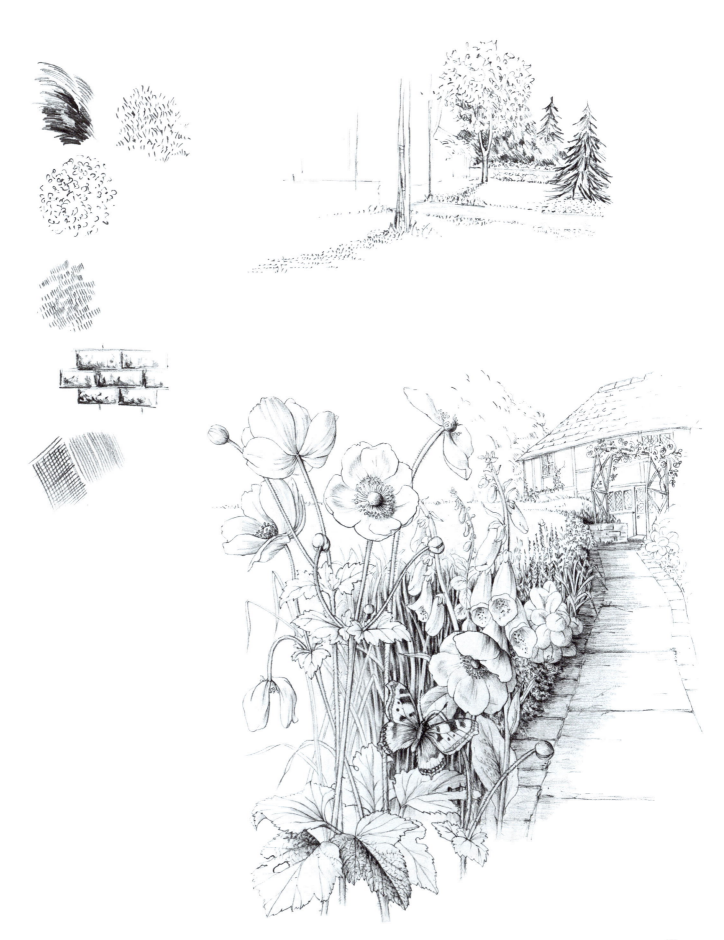

47

A final word

Rules are made to be broken. Every good artist is a good artist at least partly because of his originality; in fact, because he does what no one else has done before and because he breaks rules.

Every human being is unique. However poor an artist you think you are, you are different from everyone else and your drawing is an expression of your individuality. Good luck.

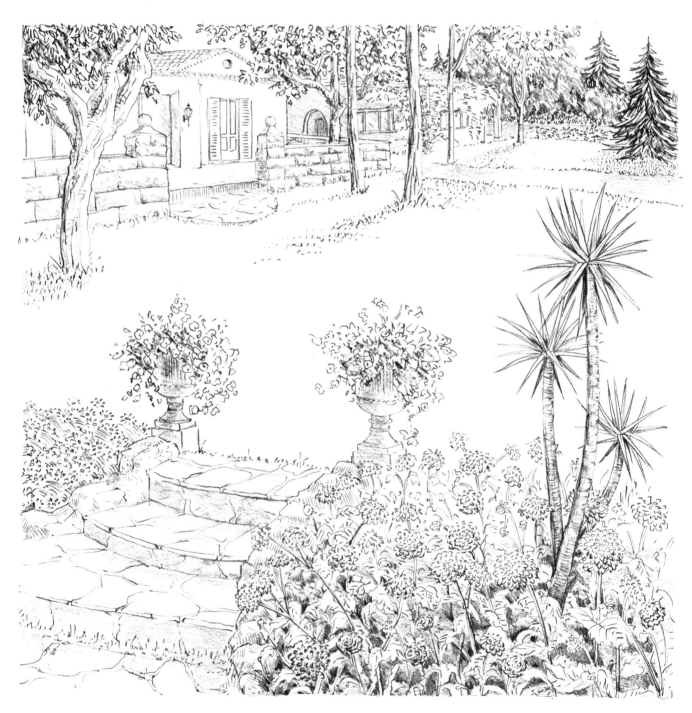